SYMBOLISM OF THE
CELTIC CROSS

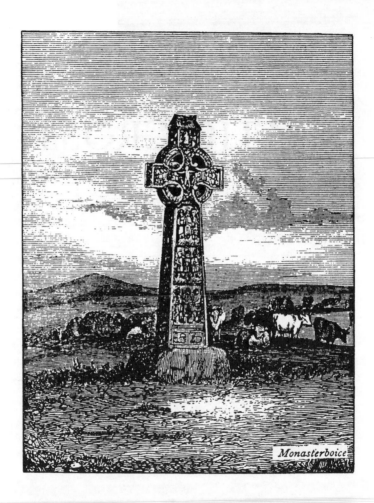

Monasterboice

SYMBOLISM OF THE
CELTIC CROSS

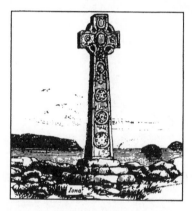

Derek Bryce

ACKNOWLEDGMENTS

The author thanks Mrs. Margaret Hall for supplying the photograph of the Langholm Mercat.
Also, Cornwall Books (Wheaton Publishers), who issued a reprint of G. Langdon's book on Old Cornish Crosses,
for permission to reproduce the drawing of the Mylor Cross.

Book first published in the United States in 1995 by
Red Wheel/Weiser, LLC
York Beach, ME
With offices at:
368 Congress Street
Boston, MA 02210
www.redwheelweiser.com

09 08 07 06 05 04 03
8 7 6 5 4 3 2

Book copyright © 1989 Derek Bryce
Package copyright © 2002 Red Wheel/Weiser, LLC

ISBN 1-59003-033-8

Manufacturing in China, by Regent Publishing

CONTENTS

Preface . 7

Chapter 1. Pillar Stones:
The World-Axis . 11

Chapter 2. Market Crosses: Heaven, Earth,
and the Space Between . 19

Chapter 3. Early Symbolism in the Celtic Church 39

Chapter 4. The Ornamentation of Celtic Crosses:
Symbolism and Beauty . 79

Chapter 5. Celtic Crosses . 111

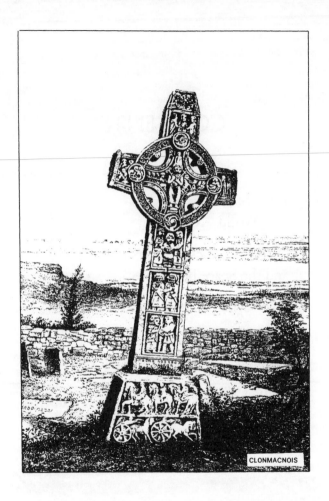

CLONMACNOIS

PREFACE

The text of this book has been written not as a work on the techniques and development of Celtic art, but with the intention of giving readers some understanding of the meaning of the Celtic cross; the basic symbolism.

By illustrating it mainly with drawings, readers have a chance to form some idea of what the ornamented crosses looked like when they were new, something which cannot be achieved by photographs of those of our ancient stone monuments that are vandalised or weather-worn.

In writing about symbolism, I have concentrated on what is basic or essential, rather than try to comment or speculate on the

meaning of every single decorative item on the stone monuments. I have restricted my comments on the fascinating range of Pictish symbols illustrated, leaving them in the purely descriptive stage. It would, perhaps, have been possible to expand on the Pictish mirror-symbol with reference to other traditions, such as the ancient Chinese description of the perfect sage being like still water and reflecting the truth to all who look at him, or the legend of the world-mirror in which all things can be seen; but interesting as such speculations may be, they do not necessarily explain the symbolism intended by the Picts themselves. Similarly, the Pictish crescent-symbol could be compared with the gold ornaments found in Ireland called "lunulae," which were probably worn slung across the chest. The V-shaped rod symbol reminds one of a broken arrow; it could represent peace, but once again this may not be the meaning originally intended by the Picts. Furthermore, if many of the Pictish symbols had become clan or family "heraldic" designs by the time they were used to decorate these stones, their original symbolism may have been pushed into the background. Mediaeval tombtones in the West of Scotland often have a sword sculptured on them to indicate a male burial, and shears, comb or mirror for a woman!

Readers will find in this book a story of the progressive development of Celtic Christian art, from very simple beginnings in the so-called dark ages, to the wonderful free-standing ornamented Celtic crosses that have survived. When comparing the earliest designs with those that followed, it is important not to jump to the conclusion that they represent a progressive development in spirituality. The earliest Christians were esoteric, taken up with internal prayer and they had little need of external symbolism, whereas later, when Christianity was changing from an esoteric sect towards state religion, it embraced people of less spiritual aptitude so that there was a greater need of the support provided by the development of Christian symbolic art.

I have retained the older county names when giving localities, purely as a matter of convenience. Most of the drawings in this book are from the works of J. Romilly Allen, especially his *Early Christian Monuments of Scotland* (1906) and his *Early Christian Symbolism in Gt. Britain and Ireland* (1889), and his article in *Archaeologia Cambrensis* entitled *Early Christian Art in Wales* (1899). Drawings of Scottish market crosses are by J. W. Small (from *Scottish Market Crosses*, 1900). The market cross at Bromboro is illustrated after Alfred Rimmer's *Ancient Stone Crosses of England*. Early Welsh

crosses are from *Lapidarium Walliae* by J. O. Westwood; also the stone from Fishguard, which is from *Archaeologia Cambrensis* vol. xiv (1883). Manx crosses are from J. G. Cummings' article in *Archaeologia Cambrensis* vol xii (1866). The Malew Paten is from the same volume, an article by E. L. Barnwell. An article by Barnwell in the same journal, vol v (1874) has provided the drawing of the Menhir of Kerloaz. The miniature from Wurtzburg is from an article by Miss Stokes in *Archaeologia* vol xliii, 1869. The high cross of Durrow is from *Early Christian Art in Ireland* by Margaret Stokes. The drawings from Clonmacnoise are from George Petrie's *Christian Inscriptions in the Irish Language.* I have also consulted W. G. Collingwood's *Northumbrian Crosses* (1927), *Pillar and Cross* by John Irwin (RILKO*, no, 33, 1988) and *Avebury, Ancient Capital of England* by Brian Ashley (RILKO, no. 33), *Sacred Stones Sacred Places* by Marianna Lines, 1992, and *The Symbol Stones of Scotland by Anthony Jackson, 1990.*

*Research Into Lost Knowledge Organisation.

PILLAR STONES:
THE WORLD-AXIS

L ong before the days of Christianity, in the Celtic West there were sacred stones. Whilst it is not within the scope of this book to discuss stone circles and alignments, standing stones or pillar stones are very relevant, for they symbolize the *Axis Mundi* or world-axis, the *pole* or link between heaven and earth. The oldest symbol of the world-axis is the sacred tree, best known as the Tree of Life. Pillar stones began to replace sacred trees when nomadic peoples settled and cleared the land for agriculture.

In Britain, pillar stones are generally of modest proportions; the one illustrated from Lampeter in Wales measures 13' 6" high

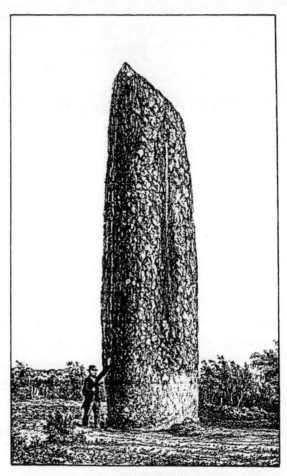

The Menhir of Kerloaz.

above the ground. However, in Brittany they are sometimes gigantic. For example, the Menhir of Kerloaz, illustrated on page 12, stands some 40 feet above the ground. It is said to have lost its upper part through having been struck by lightning.

In Britain, a stone some 22 feet high and shaped like a giant phallus, stood in the centre of the Avebury stone circle. It was broken up for building material in the eighteenth century.

Although many standing stones have survived in remote places untouched, some have been given a Christian modification or addition. Thus the Menhir of Kerloaz was surmounted by a wooden cross, replaced later by an iron crucifix. Neath cross in

Neath Cross.

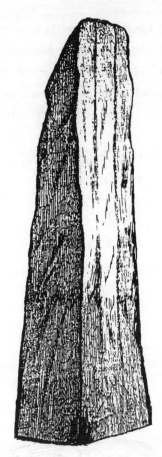

Standing stone near Lampeter.

Wales appears to be a pagan standing stone which has had a cross inscribed on it, and there are other similar examples to be found. These modifications imply that some early Christians saw the symbolism of these ancient sacred stones as not incompatible with Christianity. This is, of course, because the symbol of the world-axis is universal. Similarly, the old Roman emperors and

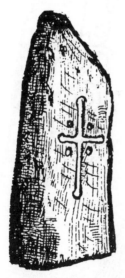

Inscribed pillar-stone, Trawsmawr, Wales.

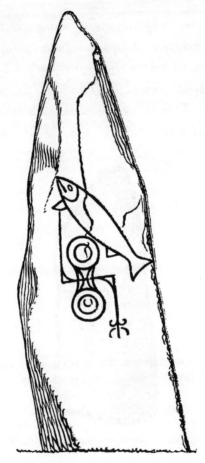

Pillar stone at Edderton, Ross, Scotland.

the popes have the title of *Pontifex* or bridge-maker between heaven and earth, which again shows continuity between pagan and Christian traditions.

Standing stones can also be found with incised symbols which are not specifically Christian, as in the example on page 16 with a fish (salmon) and Pictish symbols.

2

MARKET CROSSES:
HEAVEN, EARTH, AND THE
SPACE BETWEEN

Some of the late Victorian writers, such as J. W. Small, assumed that our stone market crosses had replaced wooden ecclesiastical crosses erected by saints in the early days of Christianity, and that they had gradually lost their Christian symbolism and become secular or civic monuments. If this were true, they would have no distinctive Celtic connection.

A modern writer, John Irwin, has pointed out that early in the nineteenth century, when amateur archaeologists began to explore the remoter parts of the west of Britain, they found sculptured stones which were obviously pagan, and some of which were clearly phallic in shape. They also found that in some places

the local people still had customs associated with them. Although the purpose of archaeology should be to record and preserve, these objects were too embarrassing for nineteenth-century gentlemen to report in the literature, and most of them were quietly made to disappear; broken and/or buried. One of the few to escape seems to have been the Clackmannan stone, situated to the east of Stirling. We reproduced J. W. Small's drawing of it, with a typical mediaeval market cross nearby. Small made no comment on the phallic shape of this stone; perhaps he did not wish to draw attention which could have been detrimental to it, and in any case he was primarily interested in the market cross. The antiquity of this stone is underlined by the name Clackmannan itself, which implies the *place of the stone*. No one knows how many of these stones, which bridge the gap between the ancient standing stones and Christian monuments, were made to disappear. We have already mentioned the great stone that once stood in the centre of the Avebury circle, and which was broken up for building material. The fact that stones of this kind survived through many centuries of the Christian era may indicate that they were not seen as offensive or embarrassing until the nineteenth century. In India where phallic stones are still

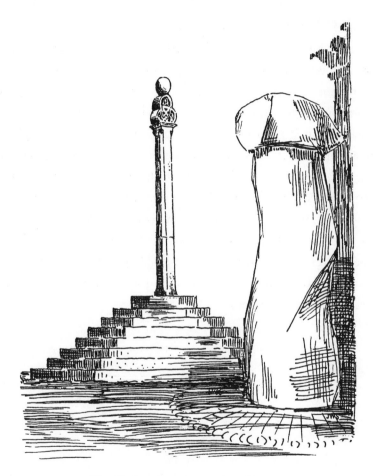

The Clackmannan stone and market cross.

venerated, they represent the world-axis under its aspect of fertility, and have nothing to do with sex in any vulgar modern sense, nor with the idea of worshipping a sex organ. In terms of the ancient Chinese tradition, they symbolize the *action* of Heaven on Earth. . . . Another stone which was dug up by road workers about 25 years after its disappearance, is the Langholm Mercat, or market cross. It was unearthed near its original site, which was the cross-roads at Langholm in Dumfriesshire. Our photograph shows that its shaft is chamfered near the bottom, leaving a square base, and on top there is a depressed sphere. Its form is clearly pagan, and a cross inscribed on top is without doubt a later Christian addition. The shape of the stone is important in establishing a link between pagan market crosses and those of the Christian era.

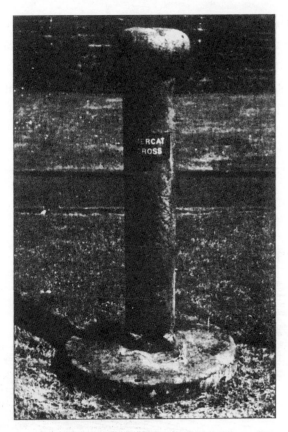

The Langholm Mercat (market cross).

Another possible pagan survival, which may have survived because it was just a block of natural stone, is the so-called market cross in the ancient village of Minigaff, about a mile from Newton Stewart in Kirkcudbright-shire. We illustrate it below; if it really is a market cross, it poses the question why they were ever called crosses at all, and we shall return to this point later.

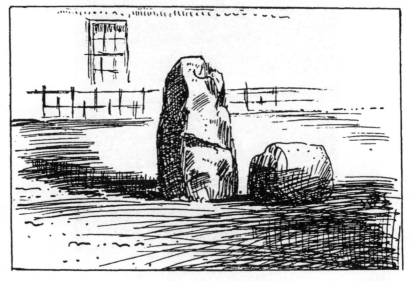

The "market cross" at Minigaff.

If we look at a large number of market crosses, although they vary in form, a general pattern emerges: A square base in the form of a stepped pyramid, although the "steps" are not always proportioned to be used as such; an octagonal shaft; and a ball or sphere on top. Of course there are many exceptions, but perhaps this common form corresponds with a pagan prototype which has not always been adhered to when crosses have been reconstructed or made in later times. The market cross at Milton, Ross-shire, is a typical example; likewise the one illustrated from Clackmannan.

The market cross at Findhorn, Elginshire, shows an exception to our general type, in that the stepped base is circular instead of square. Other variants include hexagonal or octagonal stepped bases, and square or round-section shafts.

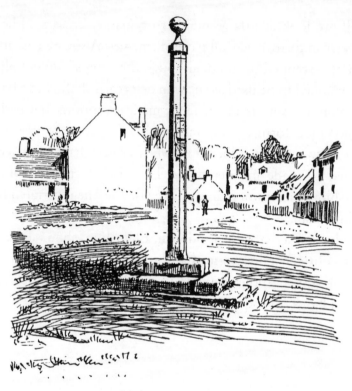

Market cross at Milton.

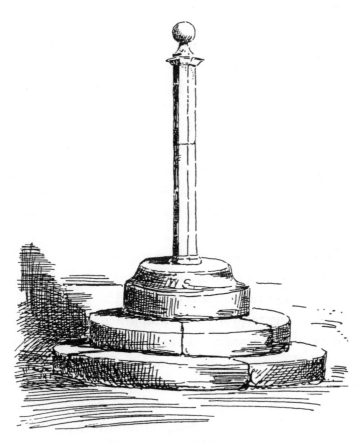

Market cross at Findhorn.

The cross at Bromboro in Cheshire stands on a stepped pyramid base, the steps of which are clearly not intended for trading. We reproduced a wood engraving of it from Rimmer's *Ancient Stone Crosses of England,* 1874. This engraving shows the cross surmounted by a sphere and sun-dial, which have since been replaced by a Latin cross.

The market cross at Wigton has a fircone above a sun-dial on top. John Irwin points out that fir cones occur on some market crosses in Belgium, and that they represent the link between the stone axis-symbol and the sacred tree, the cone being the fruit of a tree.

The basic symbolism of these market crosses, like the ancient pillar stones, is once again of the world-axis, the link between heaven and earth, but elaborated. The ancient traditional world-view recognizes three worlds, spiritual (heavenly), psychic, and corporeal. The spiritual can be *symbolized* by the sky, with the sun as symbol of divine light, the corporeal by earth, and the psychic or immediate world by air or the space between heaven and earth. Thus the sphere on top of the cross can represent heaven, or the angelic states, a sphere being the most perfect "fluid" form; it can also represent the sun. The shaft itself represents the world-

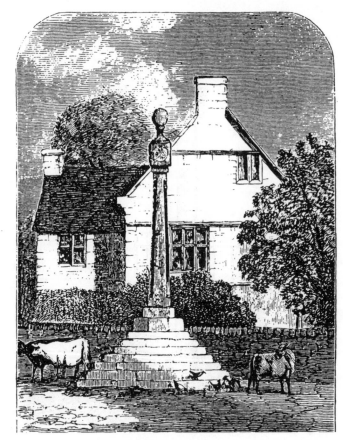

Bromboro Cross.

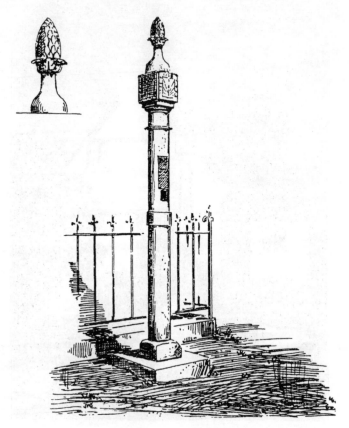

Market cross at Wigton.

axis, pole, or spiritual bridge between heaven and earth; the octagonal exterior of the shaft, however, representing the directions of space, air, the intermediate space between heaven and earth, corresponds with the psychic states. The square base represents the *fixed* earth, the corporeal state. The stepped base forming a pyramid no doubt represents the ancient sacred earth mounds known from many traditions throughout the world. On page 33 we illustrate a cross-slab from Fishguard churchyard, Pembrokeshire, where a Latin cross has been inscribed with a stepped mound, indicating that the stone mason may have considered the base an important piece of symbolism. . . . We have already indicated that some market crosses incorporate a sun-dial near the top, and there is some evidence that the sphere or ball on top of some of these crosses was originally gilded. All of this adds up to a pagan Celtic prototype being a world-axis associated with a solar symbolism. . . . The maypole, which continued in use as a children's dance within living memory, has something in common with the form of the market cross, the pole being surmounted by two hoops at right angles to one another and thereby representing a sphere. Those performing the maypole dance are, in effect, dancing in a circle around the world-axis.

Much of the symbolism we have mentioned is universal. Thus the ancient Chinese sages wore a round hat to represent Heaven, and square shoes representing Earth. Islamic mosques have a domed roof and a square base (and the famous Taj Mahal is octagonal on the inside). Readers should note that the symbolism we have described of earth, air, and sky for the corporeal, psychic, and spiritual states is not the only one; there is also the well-known symbolism from Genesis of the separation of the upper waters (spiritual) from the lower waters (psychic and corporeal).

If the market cross thus symbolises the world-axis, the link between heaven and earth, but in a more elaborate way than the older pillar stones, why, it may be asked, are they called crosses at all. A possible answer could be that they eventually came to have an ecclesiastical cross stuck on top, or replacing the top. On the continent, when the Church found that the people clung to the worship of these stones even after edicts to destroy them, their broken shafts were repaired by iron collars, and they were surmounted by a cross. In Britain many such crosses were broken off during the Cromwellian period; some were replaced in late Victorian times. . . . It is more likely, however, that they became

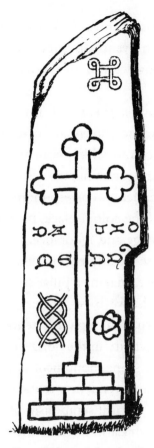

Cross, Fishguard churchyard.

known as market crosses through being situated at cross-roads, meeting places which eventually grew into our market towns. This leads us to a consideration of the vertical symbolism of the cross.

The Hindus have a theory of three *gunas* or tendencies: *sattvas,* an upward tendency, spiritual, corresponding with knowledge, light, and the colour white; *rajas,* an outward or expansive tendency, corresponding with human activity, and the colour red; *tamas,* a downward tendency, corresponding with ignorance, obscurity, darkness, and the colour black. Note that where the Hindus speak of knowledge and ignorance, Christians would speak of good and evil; these are different points of view relating to the same symbolism. If we imagine a pillar stone or market cross situated at a cross-roads, we have a three-dimensional cross, the stone itself representing the upwards tendency, the cross-roads representing human activity in the horizontal plane, and the prolongation beneath the stone monument down into the earth representing the downwards tendency, towards the infernal regions. This summarizes the vertical symbolism of the cross; it is applicable to the well-known Latin form of the cross (but we shall see

later that many Celtic crosses have a different, centrepetal instead of vertical symbolism, that of the wheel-cross).

In the ancient world there was not the clear distinction made today between sacred and secular or profane, and many human activities were carried out at the market crosses, and continued to be so even when the sacred nature of these crosses had become largely forgotten. Official proclamations were read out, rules for commerce such as weights and measures were laid down, justice and punishment were dispensed, and oaths were witnessed. Even last century, sailors from Cornwall would swear oaths on board ship on an axe, an ancient portable symbol of the world-axis. Some people may be surprised that punishments were carried out at a sacred site, but it must be remembered that in the ancient world the treatment of criminals was intended to be curative as well as punitive; in the sense that the punishment of man could alter the criminal's karma and save him or her from something more severe after death. Thus the Celts used the birch for corporal punishment because they believed this tree to have the property of driving out evil. The following extract from Joceline's *Life of St. Kentigern,* concerning a cross erected at Glasgow, may help to

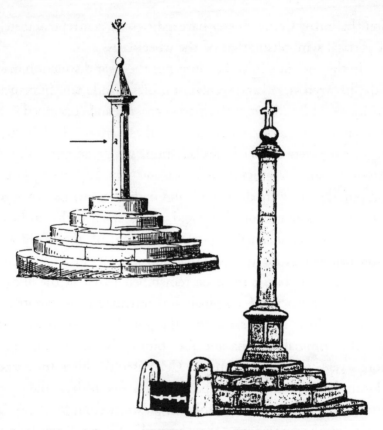

Upper left, cross at Old Rayne; lower right, stocks and cross
at Poulton-le-Fylde, Lancashire.

clarify this point: ". . . the cross was very large, and never from that time lacked great virtue, seeing that many maniacs and those vexed with unclean spirits used to be tied of a Sunday night to that cross, and in the morning they are found restored, freed, and cleansed, though oftimes they are found dead or at the point of death." Although Joceline's account does not directly refer to all criminals, it does give us some insight into what was believed. We illustrate the market cross of Old Rayne, Aberdeenshire, with an arrow indicating the point of attachment of the chain which once held wrong-doers by means of an iron collar; also the stocks and cross at the market place, Poulton-le-Fylde, Lancashire.

We end this chapter with another reproduction of a wood engraving from Rimmer's *Ancient Stone Crosses of England*, the lower part of Lydney Cross in Gloucestershire. The upper part probably consisted of an octagonal shaft supporting a cross; it was dismantled during the civil war. The base is a fine example of a stepped pyramid.

Lydney Cross.

3

EARLY SYMBOLISM IN THE CELTIC CHURCH

There is every reason to believe that a Celtic British Church existed nearly three centuries before St. Augustine landed on the shores of Kent in 597 A.D. Those who believe the Arimathean legend think that Christianity was brought to these islands during the first century by Joseph of Arimathea, and that he founded the first Christian community at Glastonbury. The legend of St. Alban, a Roman soldier, likewise implies Christianity in Britain before the end of the Roman occupation. The earliest historical record of a Church in Britain is that in 314 A.D., three British bishops were present at the Council held at Arles in France. St. Chrysostom, writing in 367 A.D., described the

British Islands as possessing churches and altars. Gildas, who wrote around 564 A.D., asserts that churches existed generally in Britain before the departure of the Romans; and Bede confirms his statements.

There were probably some Christians in Ireland before St. Patrick, but he is undoubtedly responsible for the main dissemination of Christianity there. He landed in Ireland around 440 A.D., and according to the *Annals of the Four Masters,* died in 493. The first attempt to convert the southern Picts was by St. Ninian, who landed at Whithorn early in the fifth century. He dedicated his stone church there to St. Martin of Tours, whom he had visited in Gaul. The Picts, however, were only fully converted more than a century later when St. Columba established himself at Iona; he landed there in 563 A.D. Soon after, St. Kentigern completed the conversion of the northern Welsh-speaking kingdom of Strathclyde/Cumbria, the southern Welsh being already Christian. Northumbria received its Christianity indirectly from Ireland, through Iona, when Aidan was made first Bishop of Lindisfarne by king Oswald in 653 A.D.

Thus the Celtic Church had an origin earlier and entirely independent of the Roman form of Christianity introduced by St.

Augustine. The chief points of difference were the time of celebrating Easter and the shape of the monks' tonsure, but there were also differences in the rite of baptism, the ordination of bishops, and the consecration of churches. The role of monasticism seems to have been more central and paramount in the Celtic than in the Roman church.

The Celtic calculation of Easter corresponded with that of the Roman church before the council of Nice (325 A.D.) when it was changed not on theological, but on astronomical grounds. The Celtic church, isolated from the rest of Christendom, adhered to the old calculation until the Synod of Whitby in the seventh century, when the Celts were persuaded to agree to the Roman usage.

In central England the Celtic church became extinct around the end of the fifth century, due to the Saxon invasions; the Welsh conformed to the customs of the Anglo-Saxon church at the end of the eighth century, but the supremacy of the See of Canterbury was not fully established until the twelfth century; the British church in Cornwall became subject to the See of Canterbury in the time of king Athelstan (925–940); the Celtic church of Northumberland conformed to Roman usage after the Synod of Whitby in 644 A.D., and the church of Iona in 772 A.D.

664

...he customs peculiar to the ancient Celtic church survived, ...ever, until the eleventh century.

THE FISH: OLDEST CHRISTIAN SYMBOL

Despite the Hollywood epic films which have shown early Christians scratching the sign of the cross here, there, and everywhere, before they were thrown to the lions, the fish, and not the cross, was the first Christian symbol. It was used in the catacombs of Rome during the first three centuries of the Christian era. The fish is generally accepted as a symbol of Christ. It is thought that it originated because the letters of the Greek word for a fish

$$(\H{\iota}\chi\theta\acute{\upsilon}\varsigma),$$

are the same as the first letter of each word of the phrase "Jesus Christ, the Son of God, Saviour," in Greek

$$I\eta\sigma o\hat{\upsilon}\varsigma,\ X\rho\iota\sigma\tau\grave{o}\varsigma,\ \Theta\eta o\hat{\upsilon},\ \Upsilon\grave{\iota}o\varsigma\ \Sigma\omega\tau\acute{\eta}\rho$$

But there is more to it than just that, for here we have a symbolism that can be related to the world-axis, the link between heaven and earth. In the book of Genesis we find that God separated the

upper waters from the lower waters, early in the creation. The upper waters represent the spiritual or heavenly state, the lower waters the psychic (intermediate) and corporeal states. Christ represented as the fish is thus the guide across the dangerous "waters" of the psyche, towards the heavenly state; a "horizontal"symbolism which nevertheless implies ascent, for the movement is from the lower to the upper waters. This symbolism of crossing the waters is widespread in ancient traditions; thus the verb *to navigate* is related to the Sanskrit word *nabis,* the umbilicus (navel) or centre of the world (implying the spiritual centre, a point at which vertical ascent into the spiritual world becomes possible); thus in ancient Chinese art fish are sometimes depicted jumping out of the "water gate," freeing themselves from the psychic realm, to enter the world of the spirit.

Celtic stone monuments depicting Christ as a fish are very rare. Many of the ancient sculptured stones of Scotland have fish, probably salmon, on them. One such stone, from Edderton, near Tain, illustrated on page 16, shows a fish and a Pictish symbol. There are also Christian cross-slabs from Scotland with fish and other animals sculptured on either side of the cross. It is, however, more likely that the fish and other animals on many of these Pic-

tish stones are to be related with old shamanistic practices, and that they continued into the Christian period as decorative art, although their symbolism may still have been understood in those times. The salmon figures in Celtic mythology; in the Mabinogion it is given attributes of wisdom and knowledge. There is, however, a Latin-type cross from Riskbuie, Argyllshire, with a head at the upper end, and a fish-tail at the lower end. It would seem to be an example of a Christian fish symbol.

Here is shown part of the reverse side of the cross-slab at Glamis, Scotland, with a fish, serpent and mirror.

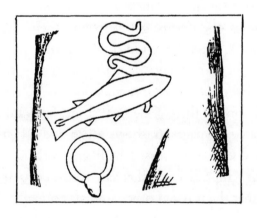

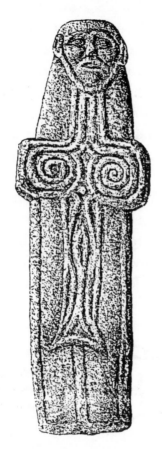

Cross from Riskbuie (later at Colonsay House).

Along the northern shore of the Firth of Forth, from Dysart to Fifeness, there is a range of caves, several of which are richly studded with incised sculpturings, including simple equal-armed crosses and others of the Latin form. There are also figures of beasts, serpents, and birds, and some of the Pictish symbols. Joseph Anderson, in *Scotland in Early Christian Times*, thinks that these caves were used as spiritual retreats by early saints. One of the caves at Cailplie was known as the Chapel Cave according to Wyntoun, and the *Aberdeen Breviary* states that the customary retreat of St. Serf was a cave. St. Serf's cave was still a resort of pilgrims at the time of Bishop Elphinstone who wrote the *Aberdeen Breviary*. What interests us here, is that in another cave, known as Jonathan's, there is a fish symbol:

Fish symbol in Jonathan's cave.

In Ireland the tombstone of Oidican at Fuerty, Roscommon, includes a fish which seems likely to be there as a Christian symbol.

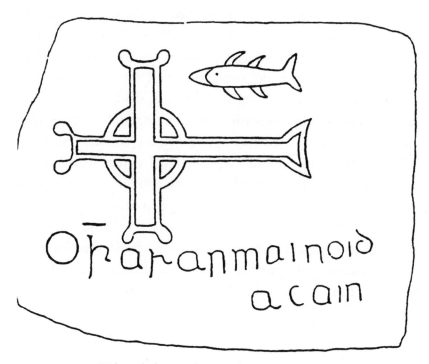

Fish symbol on tombstone of Oidican at Fuerty.

THE CHI-RHO MONOGRAM

This monogram consists of the two Greek letters **X** (chi) and **P** (rho), which are the first two letters of the name of Christ in Greek. A monogram can be formed by placing one over the other so that the vertical stroke of the **P** cuts through the intersection of the **X**. Sometimes the **X** is rotated so that one of its strokes coincides with the stroke of the **P**, the other stroke becoming horizontal. The earliest dated examples of this early Christian symbol from the catacombs belong to the beginning of the fourth century. This monogram became famous because in 312 A.D., the Emperor Constantine gained a great victory which was attributed to his having had the chi-rho monogram painted on his soldiers' shields. The monogram had previously been featured on coins, but it was Constantine's victory that promoted its use. This monogram gives us what are probably the oldest authentic instances of Christian symbolism of the Romano-British period in Britain, at Chedworth in Gloucestershire:

and at Frampton in Dorsetshire:

Here are later examples from Cornwall:

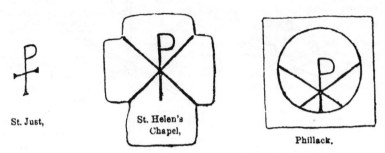

St. Just,

St. Helen's
Chapel,

Phillack.

The chi-rho monogram on stones from Cornwall.

In Wales there is a monogram on a stone from Penmachno in Gwynedd. There it is in the common form of the four-rayed cross, and not the six-rayed type. This symbol was the beginning of an art form which, in the Celtic lands, led to the production of the beautifully-sculptured crosses we shall be discussing later. What happened was that the chi-rho monogram came to be enclosed within a circle, and the curved part of the **P** became detached at its lower end, and reduced in size until it eventually disappeared, leaving a circle, or wheel-cross, originally of the type now known as the Maltese cross. The following diagram illustrates this development.

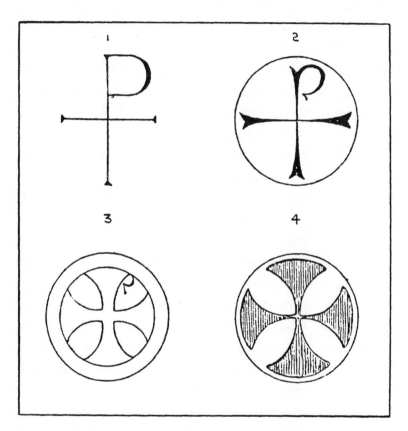

Development of cross out of monogram on stones (1) at Penmachno, (2)
Kirkmadrine, (3) Whithorn, and (4) Aglish.

A similar sequence of events can be traced in the cata-combs of Rome. This same symbol, of the wheel-cross, was also used to represent the nimbus or halo behind the head of Christ, and the saints. John Irwin points out that this symbol is very similar to the Assyrian rayed cross, which dates from many centuries before the Christian era, and is considered to be a so-lar symbol. This symbol is believed to have come into Byzan-tine via Persia, to represent the nimbus on icons; but it may have a dual origin, for there is a head of Christ with a nimbus formed of the chi-rho monogram on a mosaic in the church of S. Aquilino in Milan.

Thus the early Christians had, albeit unintentionally, arrived at an ancient solar symbol by developing the chi-rho monogram. The wheel-cross has therefore, in its origin, nothing to do with the crucifixion. As a solar symbol it has a lot to do with the rep-resentation of Christ in Majesty, Divine Light, but it should go without saying that the early Christians probably never looked upon it in any terms other than this.

In the symbolism of the wheel, the point at the centre rep-resents the Most High God, the motionless mover, for the

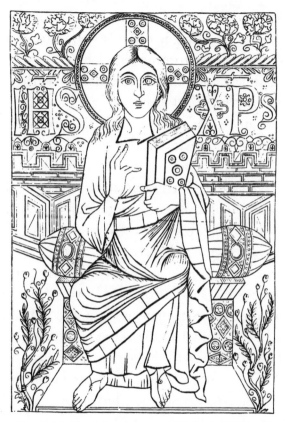

Wheel-cross nimbus behind head in miniature of Christ in Majesty from ms. written for Charles the Great by Godesscalc; oriental influence on Celtic art.

point at the centre has no dimensions and cannot turn, yet all moves around it. Movement towards the centre is against the centrifugal force of the turning wheel, away from it is towards the outer darkness. Movement towards the centre requires effort against the centrifugal force, whereas the opposite requires no effort at all. Compare this with the upwards movement against the pull of gravity in the vertical symbolism of the cross. . . . The symbolism of the wheel, in the eastern traditions, is often applied to universal existence; in the case of Christian sculptured crosses, the intention is generally that of the derivation of the symbol—a representation of Christ, with the emphasis on divine radiance.

Once the Celtic Christians realised that this ancient symbol of the wheel-cross was not incompatible with their religion, they began also to use its more ancient form, the swastika, which is believed to be the symbol of the wheel from the time before the wheel had been invented for locomotion, the bent-over arms of this cross implying rotation around a central point. We illustrate a stone from Aglish, Co. Kerry, which shows an early Maltese cross and two swastikas.

Circular cross on stone at Aglish.

In the preceding drawing of the stone from Aglish note the arrow pointing upwards towards the cross. It was not long before a vertical line was added to these early crosses, representing the world-axis, and giving them a similar symbolism to the pre-Christian maypole, and our prototype of the pagan market cross, in which the solar orb is replaced by a symbol of Christ in Majesty. We illustrate some examples from Wales:

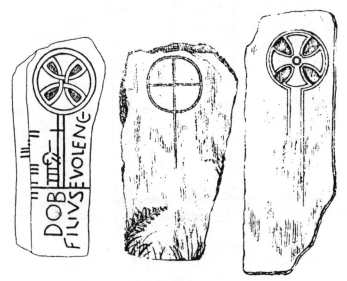

Stones from Dugoed, St. Non's church, and Nevern.

A stone from Port Talbot, Wales, has the symbolism changed by the addition of two leaves or side-branches to the base of the axis, turning it into a flower. The meaning of the symbol is, however, little changed, for Dante represented God in the highest heaven, surrounded by angels forming the petals of a flower calyx. The other side of this stone shows a wheel-cross derived from the six-rayed version of the chi-rho monogram:

Stone from Port Talbot.

THE LATIN CROSS

The Latin cross, which can be related to the traditional form of the crucifixion, also figures on some Celtic stones. We illustrate a few examples from Wales:

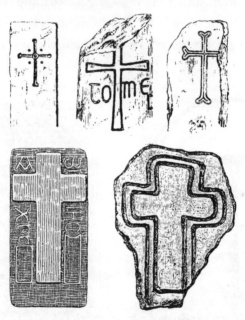

Latin crosses on stones from Strata Florida, Port Talbot, Pen Arthur, St. Edrens, and Goodwick.

THE CRUCIFIXION

Representations of the crucifixion do not occur amongst the paintings in the catacombs of Rome during the first four centuries.

During the fifth and sixth centuries, the Agnus Dei or Lamb of God is used to represent Christ on the sculptured sarcophagi of Rome. The lamb is seen first with the chi-rho monogram on its forehead, then with a Latin cross on its forehead; then the Lamb is seen carrying a cross on its shoulder, then placed on an altar, with blood flowing and a cross behind it; finally the Lamb is seen enclosed within a medallion forming the centre of a cross. The next step was to substitute the figure of Christ for the symbolical Lamb. The Quiniset Council, held at Constantinople in 683 A.D., decreed: "We pronounce that the form of Him who taketh away the sin of the world, the Lamb of Christ our Lord, be set up in human shape on images henceforth, instead of the Lamb formerly used."

The traditional portrayal of the crucifixion is clearly connected with the Latin cross, which can easily be understood as derived from the monogram if we look at just two examples

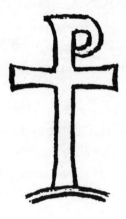

above, the one on the left from the catacombs, the other from the church of S. Aquilino, Milan.

Once again, we see the curved part of the **P** separating and becoming smaller, this time leading to the Latin cross.

In Britain there is a unique instance of the Lamb of God on a cross, on a sculptured slab in Wirksworth church, Derbyshire:

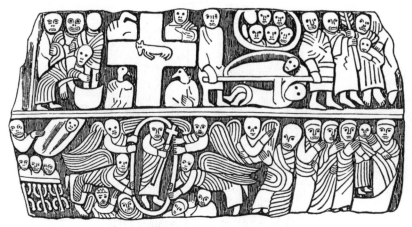

Early sculptured slab at Wirksworth.

But to return to Celtic lands, we can see how the wheel-cross, derived from the chi-rho monogram, and a symbolic representation of Christ, may be connected with the traditional form of the crucifixion.

We illustrate a wheel-cross from St. Edrens, Wales, in which

the arms of the cross have been extended beyond the circle into the form of a Latin cross.

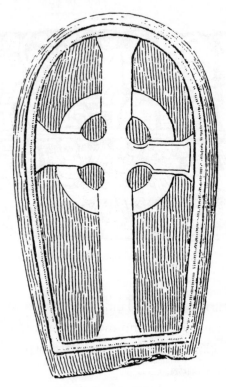

Stone from St. Edrens.

If we now look at the cross from Pont Faen, Wales, we can relate it with the previous one if we assume that the wheel, representing Christ, has been reduced so as to fit into the centre of the cross, equivalent to the Lamb in the centre, mentioned above.

Cross at Pont Faen, Pembrokeshire.

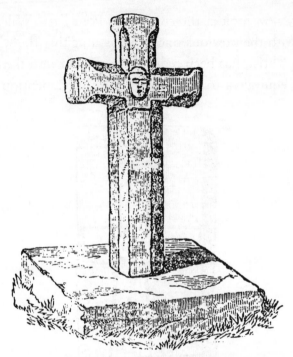

Cross at Bosherston, Pembrokeshire.

In Celtic sculpture, the head or face of Christ may have been depicted first, before the whole figure. The cross illustrated from Bosherston, Wales, shows a face in place of the symbolic representation of the circle, or Lamb mentioned above. It is worth noting that the shaft of this cross is octagonal, and the base square, implying that it is a representation of Christ on the world-axis, and conforming to our original prototype market cross.

Thus we have arrived at the idea of a representation of Christ on the Latin cross, the traditional form of the crucifixion. The cross has been derived from the chi-rho monogram, itself a symbol of Christ, but also a symbol of the world-axis. The fact that Christ is portrayed as *fixed* to the cross by nails, implies that he became *one* with the world-axis.

Many of the later representations of the crucifixion show Christ suffering or apparently dead, and naked except for a simple cloth around the waist. The early Celtic representations show Christ in triumph, often clothed, sometimes magnificently so, and with his eyes wide open. The following illustrations speak for themselves:

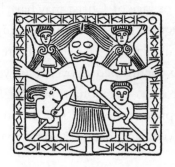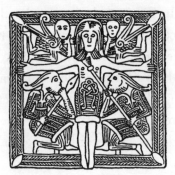

Crucifixion on metal plates in the Museum of the Royal Irish Academy.

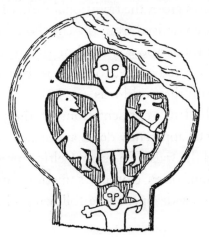

Crucifixion on cross at Llangan, Wales.

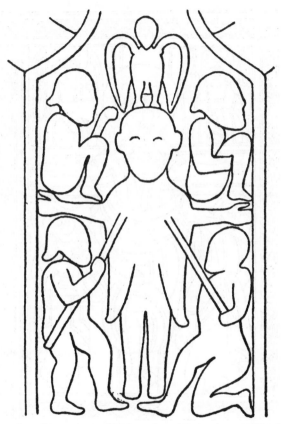

Crucifixion, cross of SS Patrick and Columba at Kells.

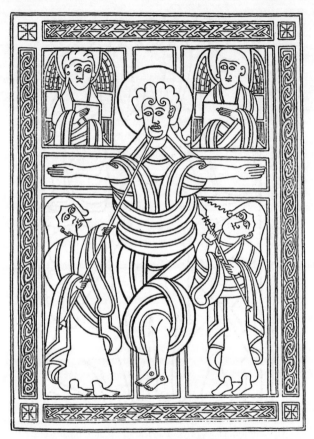

Crucifixion, from the St. Gall Gospels.

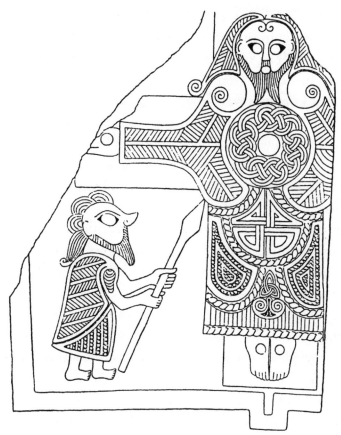

Crucifixion on slab of slate, the Old Chapel, Calf of Man.

In the Crucifixion from the St. Gall Gospels, a wavy line can be seen passing from Christ's side to the eye of the soldier holding the spear. The soldier's name is said to be Longinus, which seems to be derived from the Greek word for a spear. A legend states that Longinus was blind; that he struck Christ by accident, and that blood fell onto his hand, his sight returning when he rubbed his eyes with it. This no doubt refers to spiritual blindness, for a blind soldier would hardly be in the Roman army. In the St. Gall Gospels the wavy line shows blood spurting directly into his eye.

In the highly-stylized, incomplete crucifixion from the Calf of Man, the circular breast adornment shows a void in the middle, representing the heart as spiritual centre; a return to the symbolism of the wheel.

A striking feature of many of the early Celtic crucifixions is that the lance and the pole of the sponge-bearer stand out to form a triangle or pyramid. This leads us to another symbolism concerning the link between heaven and earth; that of the two triangles. Here is a sandstone pebble from Broch of Burrian, Scotland, with this symbol in its best-known form:

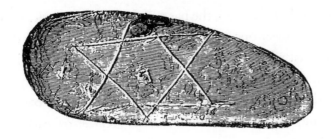

And here is a more elaborate example from a Chinese lattice design, just to emphasize the universality of this symbol:

And here is another way of representing the two triangles:

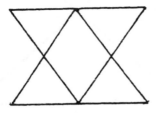

In this last diagram, the base of the upper triangle represents heaven, the lower one earth. This form of the symbol is designed to show that what is greatest in heaven (represented by the upper horizontal stroke) is smallest on earth (represented by a point where the tip of the upper triangle touches the base-line of earth); and vice-versa (i.e. what seems greatest on earth appears insignificant in heaven).

The two triangles may also be drawn with their points just touching, the upper triangle representing heaven, the lower one earth:

In this representation, the link between heaven and earth is the point of intersection, symbolizing the "straight and narrow gate" on the way from an earthly to a heavenly state. The triangle formed by the lance and sponge-pole in some of the early crucifixions thus represents the way to the gate of heaven. This symbolism can also be applied to the pyramid of steps beneath market crosses, and to ancient sacred mounds like Silbury hill. When steps are present, they may well symbolise the steps or stations on the first part of the spiritual journey; we say first part, for the true spiritual journey, the second part, is through the heavenly states.

When looking at these early crucifixions, it is important to note that the Celtic artists and artisans who produced them were not in any way attempting to reproduce the execution of Christ as it might have happened in history. What they were doing was portraying Christ on the world-axis, triumphant over death. On the following page is yet another Celtic crucifixion, to emphasize this point. It is from an illuminated manuscript in the library of Würtzburg. Our reason for stressing this point is that there are some critics of traditional Christianity who point out that in the original Greek of the New Testament, Christ is described as be-

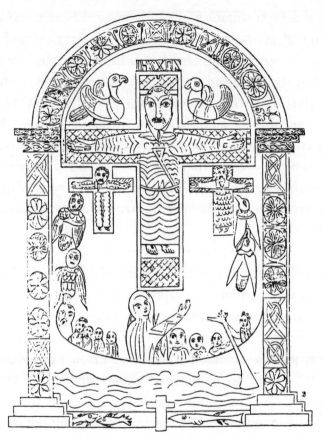

Crucifixion, Irish manuscript at Würtzburg.

ing executed on a stake or pillar, there being no mention of a cross-bar. It was only when the gospels were translated into Latin that the word *crux*, or cross appeared. Some of the critics imply from this that the Church fabricated the idea of the crucifixion. It is possible that the translators into Latin merely *assumed* that the stake must have had a cross-bar; it is however possible that they had access to oral tradition concerning the event that has since been lost; but what is important is that the Greek texts describe the *essential*, that is, Christ dying fixed to a symbol of the world-axis. It would seem possible that the traditional form of the crucifixion came from depicting Christ on the Latin cross, itself derived from the chi-rho monogram. The Latin cross is thus a symbol of Christ and of the world-axis. The cross-bar adds another dimension to Christ, horizontal, embracing the souls of his followers; whereas the vertical dimension of Christ united with the world-axis provides them with the way to heaven.

Stakes were commonly erected permanently at execution sites throughout the Roman empire, and this perhaps makes the story of carrying a cross to the site unlikely; one recent view is that what Christ may have carried was a heavy cross-bar to be added to an existing stake.

If we compare these early crucifixions, with Christ wide-eyed and clothed, with later ones nearly naked and suffering, some literal critics could well say that one of them is wrong; but they are both right once one realizes that they are *not so much representations of historical facts as two works of sacred symbolic art;* the former depicting Christ on the world-axis triumphant over death, the latter Christ suffering on the axis for the souls of the world.

It is worth mentioning that the oldest-known crucifixion is on an ivory plaque in the British Museum. Art critics date it late fifth, or sixth century. It shows Christ crucified on a wheel cross! We illustrate here a wheel-cross crucifixion from a sculptured tombstone in Meifod church, Wales.

Wheel-cross crucifixion, Meifod church.

Paten from Llanelltyd, Wales.

Here is an ancient paten or sacramental wafer-dish believed to have belonged to the monastery of Llanelltyd in Wales. It was made by Nicholas of Hereford, and shows Christ surrounded by a six-rayed floral design which can easily be derived from the chi-rho monogram.

And here is the design in the centre of a paten from Kirk Malew, Isle of Man. Once again we see a six-rayed floral design, and the ornamentation within it is clearly solar.

Centre of the St. Lupus paten, Kirk Malew.

4

THE ORNAMENTATION OF CELTIC CROSSES: SYMBOLISM AND BEAUTY

In this chapter we shall be looking at the types of ornamentation found on Celtic crosses, but it is not our purpose to describe the methods of construction of Celtic design; that information can easily be found elsewhere. We shall restrict ourselves to an illustrated account of the ornamentation from the point of view of aesthetic symbolism.

The principal types of ornamentation are plaitwork, knotwork and key patterns, swastika and spiral designs, animal and plant designs, figures of people such as saints, scriptural scenes, and hunting scenes.

PLAITWORK

The idea of plaitwork no doubt comes from weaving, which itself has a profound symbolism. It is usually plain weave that is imitated. Here is an example of regular plaitwork from Llantwit Major in Wales:

Regular plaitwork from Llantwit Major.

Like that of weaving, the basic symbolism is that of "the great cosmic loom of the universe," but it is important also to note that there are no loose ends, and the symbol is also one of continuity of the spirit throughout existence. The continual note

or drone maintained behind the music of bagpipes expresses the same idea.

Plaitwork is not always regular. By breaking some of the "threads" and joining them up in different ways, irregularities can be produced, as in this panel from the cross-shaft at Golden Grove, Carmarthenshire, Wales:

Irregular broken plaitwork from Golden Grove.

The overall effect is still pleasing. Such breaks on regular plaitwork may initially have been mistakes, or they may have been deliberately sculpted in order to imitate nature; a flower, for example, may look attractive and symmetrical, yet not one of its petals is *exactly* identical with any other. The builders of our medieval cathedrals likewise introduced slight imperfections in the dimensions, with the same end in view, yet their result is, like a flower, pleasing to the eye. The idea seems to be that perfection belongs to God alone.

Sometimes breaks are made at regular intervals in plaitwork, and this has the effect of breaking up a large surface pattern into smaller units.

KNOTWORK

Knotwork seems to have been developed from plaitwork by making multiple breaks at regular intervals. It is one of the striking features of Celtic Christian art. The knots are generally endless, and thus cannot be untied. Here the symbolism is of the knots which bind the soul to the world. Like the Gordian knot cut by Alexander the Great, these knots must be cut or broken

for the soul to become free to begin the spiritual journey. Here is an example of circular knotwork:

Panel of circular knotwork in centre of front of cross at Nigg, Scotland.

Here is an example of triangular knotwork:

Triangular knotwork from Dunfallandy, Perthshire, Scotland.

CHAIN-LINK PATTERNS

Interlocking circles forming chains, when they appear on Celtic crosses, are generally a sign of Scandinavian influence. Here is an example from a cross at Penmon, Anglesey:

Chain-link design, Penmon.

KEY-PATTERNS

Key patterns are so-called because of their interlocking nature.

The classical square key-patterns, in which the lines run horizontally and vertically parallel to the margins, were seldom used by the Christian Celts, but there are good examples on one of the crosses at Penmon, Anglesey:

Square key-patterns from Penmon.

The first step in the development of the Celtic key-pattern was to turn the Greek fret through an angle of forty-five degrees so as to make the lines run diagonally with regard to the margins, instead of parallel with them. We illustrate a key-pattern in this stage of development from an anglian cross-shaft which used to be at Aberlady, Haddingtonshire, (and was later removed to Carlowrie Castle, Midlothian). The result is striking, but it leaves large triangular areas without ornament all around the edge. When these triangles are partly filled in by bending the ends of the diagonal lines round to run parallel with the margins, we get a characteristically Celtic pattern such as the one on the great cross-shaft at St. Andrews, Fifeshire. Finally, when the opposite

Key-patterns

(1) Aberlady, Haddingtonshire (2) Abercorn, Linlithgowshire
(3) St. Andrews, Fifeshire (4) Collieburn, Sutherlandshire

ends of the diagonal lines are bent round in a similar manner, the most typical of all the Celtic key-patterns is produced, like the one on the cross-slab at Farr, Sutherlandshire.

Next to interlaced work (plaits and knots) the key pattern is the most common motive used in the decorative art of the Christian Celts.

We illustrate below the ornament on the erect cross-slab at Rosemarkie, Ross-shire. It has interlaced work around the cross,

Ornament on erect cross-slab at Rosemarkie.

Key-patterns

(1) Rosemarkie, Ross-shire (2) Farr, Sutherlandshire
(3) Gattonside, Roxburghshire (4) Nigg, Ross-shire

and a key-pattern all around; it indicates that the sculptors often used ideas from the pages of Celtic illuminated manuscripts.

THE SWASTIKA AND THE SPIRAL

We have already pointed out that the swastika occurs on Christian Celtic stones from quite early times, and that its symbolism is like that of the wheel-cross.

Sometimes key-patterns incorporate the swastika as in the following example which is common to several crosses in South Wales, including the one at Nevern:

Square key-pattern of swastika type.

An interesting development, showing four men placed swastika fashion, occurs on a recumbent monument at Meigle, Perthsire:

Four-man swastika at Meigle.

So far we have illustrated the swastika in its four-rayed form, but the Celts also had the three-rayed type, best known from the Legs-o-Man but often in the form of a spiral. Spiral designs were highly developed by the pre-Christian Celts, but many of the spiral designs of the Christian period are clearly related to the three-rayed swastika. The symbolism of these spirals, which

are little more than curved swastikas, is, once again, that of the "motionless mover," the Principle, the Most High God, in the centre, around which all things revolve. The spiral emphasizes the movement. It seems likely that the spiral designs on Celtic crosses were taken originally from Celtic illuminated manuscripts. Here below is a design from the Book of Durrow for comparison with one from a boss on the Nigg cross:

Upper left, spiral ornament from the Book of Durrow; lower right, from a boss on the Nigg cross.

Here are two more examples of spiral designs, from Nigg, and Shandwick, Ross-shire:

Nigg, boss with spiral and interlaced work.

Shandwick, panel with spiral ornament.

ANIMAL AND PLANT DESIGNS

The Celts seem to have preferred interlaced work and key-patterns for decorating cross-shafts, and foliage is but rarely used.

Animals figure rarely on crosses in Wales, but they are met with in Ireland and Scotland. We have already pointed out that many Pictish stones have fish and quadrupeds sculptured on them, and they include both known and fabulous types. In his *Myths and Legends of the Celtic Race,* Rolleston has pointed out that some of the earliest Christian poems from Ireland show respect for the Druids. Perhaps the occurrence of shamanistic animal designs on early Christian Pictish inscribed stones indicates a time when the old and new traditions were existing together. This type of design may have continued in use later, for purely decorative reasons. Readers will see examples of Pictish animal designs in the next chapter. We illustrate below a so-called Elephant symbol from the cross-slab at Shandwich, Ross-shire:

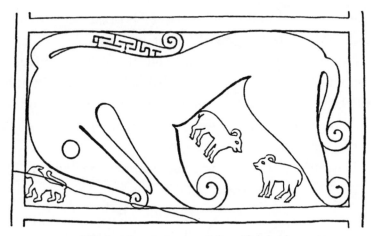

"Elephant" symbol on panel from Shandwick.

We shall return to animals when we consider hunting scenes at the end of this chapter.

PICTISH SYMBOLS

As well as animal symbols, there are some specific Pictish symbols, which include domestic and related items, as well as certain peculiar symbols. Many of these symbols can be found

on early inscribed stones with no clear Christian connection, and also decorating the margins of Christian cross-slabs.

Domestic items which occur frequently include a mirror and a comb. The inscribed stone on the left below, is from Dunrobin, Sutherland; it shows a fish, tuning fork, mirror and comb. The one on the right is from Upper Manbean, Elgin; it shows a fabulous fish-animal, a comb, and a mirror.

It is difficult to imagine these reccurent symbols as purely

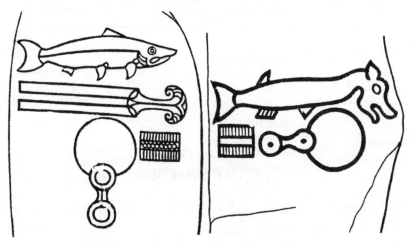

Incised stones from Dunrobin and Upper Manbean.

representative art without any underlying meaning. It is possible that the symbols used by the Picts had symbolic meanings in themselves, like the salmon mentioned earlier as a symbol of wisdom and knowledge; but it would seem likely that these Pictish symbols, singly or in special combination, were the signs each of a family or clan, like the heraldic designs of a later period, and perhaps also like trade marks, for the same designs could have been artefacts, clothing, or the sales of trading ships. This idea is developed in *The Symbol Stones of Scotland* by Anthony Jackson.

Other characteristically Pictish symbols include a crescent with a V-shaped rod, and various types of rectangle. We give an example below from an incised stone from Clynekirkton, Sutherland, which was taken to Dunrobin Museum:

Incised symbols from Clynekirkton.

The other common symbols are a Z-shaped rod, and two discs linked together. We show them below in combination from an incised stone at Anwoth, Kirkcudbright. It is tempting to think of these V and Z-shaped symbols as broken arrows, symbols of peace, but to so describe them may not be what the Picts had in mind and it could colour the imagination of future investigators, thereby preventing them from seeing them in some other light.

Incised symbols from Anwoth.

On the next page we illustrate the symbols on a panel from the back of the top slab of the Rosemarkie cross (No. I).

FIGURES

Figures, of course, occur in scriptural and hunting scenes on crosses, and we shall look at them shortly. Here we wish to draw attention to figures of early saints from Wales, with their arms held up in the ancient attitude of prayer. Here is an example from a stone at Gnoll Castle:

Stone carving, Gnoll Castle.

Symbols on panel from Rosemarkie.

And here are two further examples, from stones at Llanhamlach (left) and Llanfrynach (right), both from Brecknock:

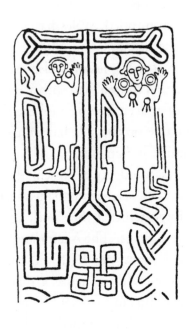
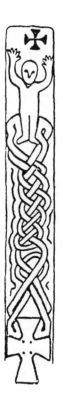

Stones showing ancient attitude of prayer.

The symbolism of this ancient attitude of prayer may be that of the chalice, for, if the elbows and hands are rotated forwards until they touch, the movement scribes an invisible cup or receptable, to receive the blessing from above.

There is another cross from Flintshire in Wales, known as the Maen Achwyfan. This cross from north Wales has a chain-link pattern on one side, indicating Scandinavian influence. The critics do not rate it among the best examples of Welsh crosses. Panels on the front and one side, each show a man with arms upraised as in the ancient attitude of prayer. The man on the front seems to be holding a spear; the one on the side has an axe between his legs. Nineteenth century writers such as J. Romilly Allen concluded that these figures could not represent the ancient attitude of prayer because they seemed to be associated with weapons; perhaps he had forgotten that the saintly monks of the early Celtic church carried arms. The Victorians were probably also embarrassed by the figure on the front, for the nineteenth-century drawings of it showed the figure as that of a naked man. W. G. Collingwood's drawing (c. 1927), perhaps based on a more careful scrutiny, shows him clothed and holding a spear in his right hand. We leave the interpretation of this fig-

ure, with the sole comment that the axe, as already mentioned, can signify the world-axis. Here is a drawing of part of the south side of the cross, showing the man and axe.

SCRIPTURAL SCENES

Many of the high crosses of Ireland are "crosses of the scriptures," a descriptive term taken from the *Annals of the Four Masters*. These crosses are decorated with panels illustrating scenes from stories in the Bible. They were no doubt intended as

a means of disseminating scriptural knowledge at a time when most of the people were illiterate. Here are a few examples:

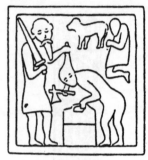

The Sacrifice of Isaac, on the shaft of the great cross at Monasterboice.

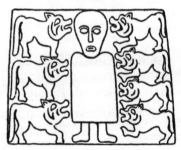

Daniel in the Lion's Den on the base of the Moon Abbey Cross.

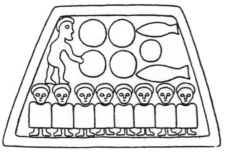

Miracle of the loaves and fishes, on base of Cross at Castledermot, C. Kildare.

Some Scottish crosses have scriptural panels:

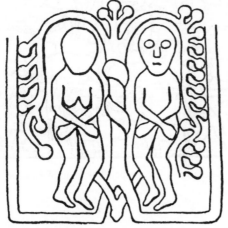

Temptation of Adam and Eve on shaft of cross at Iona.

HUNTING SCENES

Hunting scenes, and others depicting human activities, fabulous animals, and so on, occur on the Irish and Scottish crosses, but rarely on the Welsh ones which are mainly sepulchral. Here are some examples:

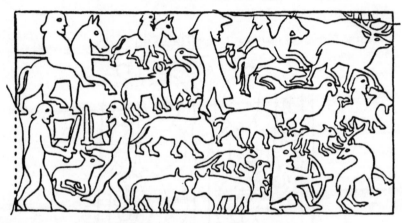

Hunting scene, etc, on panel of Shandwick Cross.

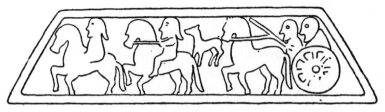

Chariot on base of cross of SS Patrick and Columba at Kells.

Man, fabulous animal, and centaur on base of cross of Muiredach at Monasterboice.

We end this chapter with a hunter, a boar, and other animals, and several Pictish symbols, all on the cross of Drosten, at St. Vigeans, Forfarshire.

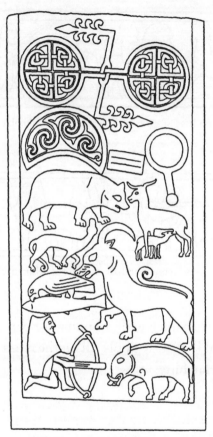

Wild boar on cross of Drosten.

5

CELTIC CROSSES

By Celtic crosses, we mean crosses which show characteristic types of Celtic ornament, whether they are inscribed on rough blocks of stone, on recumbent or erect stone slabs, or are shaped into Celtic crosses as commonly understood.

EARLY CELTIC ORNAMENTED CROSSES

The tombstone of Daniel in the cemetery at Clonmacnois, Ireland, is decorated by a cross composed of a double band, forming knots at the ends of the arms, and passing through a cir-

cular ring in the centre. It is composed entirely of simple inter-laced work, without any surrounding margin:

Cross on tombstone at Clonmacnois.

The Glendalough stone, also from Ireland, is composed also in a similar way, but there is a separate circle in the centre, and the design includes a rectangular margin.

There are similar recumbant cross-slabs on the Isle of Iona, and in Wales. The one at Iona has the interlaced circle in the cen-tre replaced by a square.

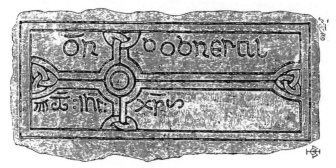

The Glendalough stone.

Here is another recumbent cross-slab from Iona, with a circle, and the interior decorated by interlaced work:

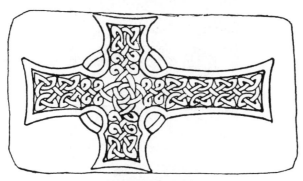

Cross-slab at Iona.

The tombstone of St. Berechtir at Tullyease, Co. Cork, Ireland, is one of the earliest dated examples of Celtic ornamentation which have survived. Berechtir is supposed to have been one of the three sons of a Saxon prince who left England after the defeat of Colman, Bishop of Lindisfarne, by Wilfred of York, at the Synod of Whitby in 664 A.D., but his death is recorded on the 6th. December, 839 A.D.

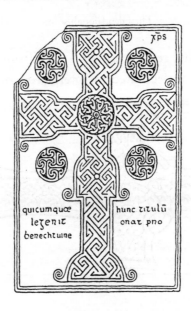

The tombstone in question bears the name of "Berechtvire." It is a beautiful example of early Celtic ornamentation. The cross is covered with a diagonal key-pattern, and a central circle is filled in with a wreath of interlaced work, but leaving a small central circle to symbolise the "motionless mover." There are four circles in each of the corners, decorated, and probably symbolic of the wounds of Christ.

The cemetery at Clonmacnois contains a large number of decorated tombstones. Many of them are inscribed, so that they can be dated with reference to the various Irish Annals, especially the *Annals of the Four Masters*, the *Annals of Ulster*, and the *Annals of Tigernach*. The dating of these stones has been of value in elucidating the development of styles of Celtic art. We illustrate a few examples from Clonmacnois, taken from *Christian Inscriptions in the Irish Language* by George Petrie (1872). The fragment below, with the letters TUI could be either (Mael)tui(le), abbot of Clonmacnois who died in 874, or Maeltuile son of Colman who died in 921. Note the spiral patterns forming the central feature of this cross.

Stone of ?Maeltuile, Clomnmacnois.

The stone of Retan or Redan, who died in 954 according to the *Annals of the Four Masters*, or 955 according to the *Annals of Ulster*, shows a beautiful endless knot forming a cross:

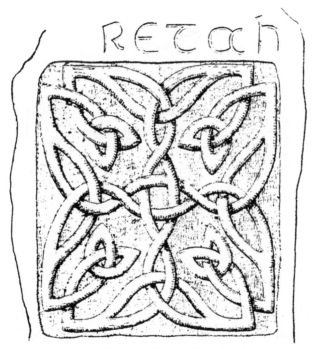

Cross of Retan or Redan, Clonmacnois.

The cross of Maelfinnia, or servant of Finnia, who died in 991 according to the *Four Masters,* shows interlaced knotwork in the centre:

Cross of Maelfinnia, Clonmacnois.

Finally, we illustrate the cross of Maelmaire, who died in 1106 according to the *Four Masters.* It shows a single three-rayed spiral in the centre.

Cross of Maelmaire.

CROSSES WITH PICTISH SYMBOLS

The cross illustrated below, with Celtic decoration and an ornamented circle in the middle, is on a pillar-stone from Monymusk, Aberdeenshire. It is accompanied by two Pictish symbols, the lower of which looks like a decorated dish with two circular handles, but which is often regarded as representing a cauldron, symbol of renewal or rejuvenation.

Monymusk; ornamented cross and symbols.

The cross-slab from Skinnet, in the far north-east of Scotland, though incomplete, is beautifully decorated with interlaced work and knots; on the back there is a Pictish crescent and V-shaped rod.

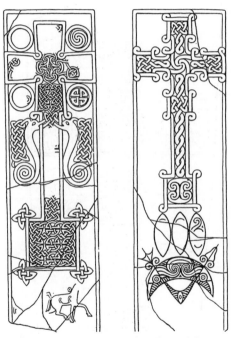

Cross-slab from Skinnet, in the Thurso Museum.

This cross-slab from Ulbster, which was also taken to Thurso, has a cross on the front decorated with interlaced work and a key-pattern. Outside the cross are people and animals. The

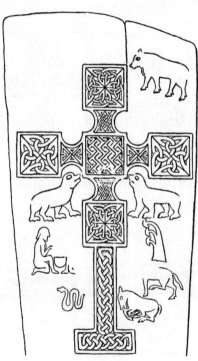

Front of cross-slab from Ulbster.

back also has a cross of triangular knotwork; it is surrounded by animals and Pictish symbols, including the crescent and V-shaped rod, and the double disc with three-rayed spirals.

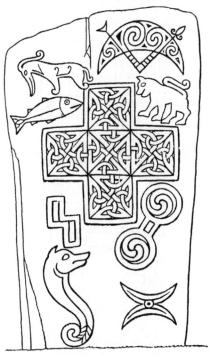

Back of cross-slab from Ulbster.

Dug up during street repairs in 1828, this cross-slab was taken to Elgin cathedral. The front has a cross decorated with interlaced work similar to that on the base, which is too defaced to be drawn. The figures would seem to be the four Evangelists: the bird is probably the eagle, symbol of St. John.

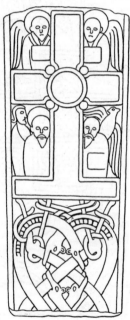

Front of cross-slab in Elgin Cathedral.

The back of this cross-slab shows Pictish symbols, including the double disc and Z-shaped rod, and the crescent and V-shaped rod. There is a hunting scene below, with a hawk, dogs, and a stag.

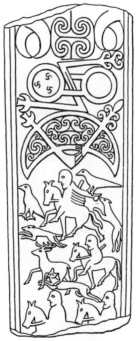

Back of cross-slab in Elgin Cathedral.

MORE SCOTTISH CROSS-SLABS

J. Romilly Allen took the view that the designs on the Scottish cross-slabs were in imitation of the pages of Celtic illuminated manuscripts, and the slab illustrated below, from

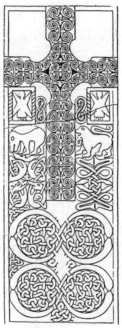

Shandwick, front of cross-slab.

Shandwick, Ross-shire, along with the one from St. Madoes, and the Farr Stone, illustrate this point well.

The cross-slab from St. Madoes, Perthshire, is a superb example of Celtic art. The animals decorating this cross may have been put there as decoration to attract the interest of the people; or they may have been intended to have a protective function like the gargoyles of the medieval cathedrals.

The Farr stone, from Sutherland, is yet another fine piece of Celtic art. Around the outside of the cross there is interlaced work merging into rams-horn designs, with a simple key-pattern above, and a more developed Celtic one below. The cross has interlaced decoration and a central three-rayed spiral swastika.

The symbolism of the Farr cross is interesting. The shaft, representing the world-axis rises up to the circle of heaven, with the spiral swastika in the centre representing the Divinity. In addition, the shaft rises from a hemispherical mound, equivalent to the stepped pyramid beneath market crosses, with two winged beasts with their necks intertwined inside the mound. This symbolism is perhaps reminiscent of Vortigern's tower in the Arthurian legends; the tower would not stand up for Vortigern because he had not subdued the beasts beneath, had not achieved

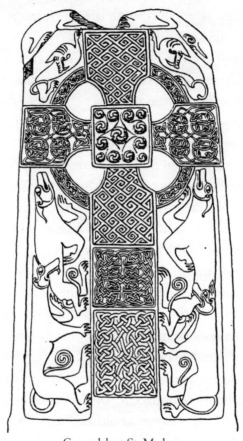

Cross-slab at St. Madoes.

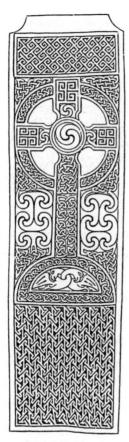

The Farr Stone.

peace within himself. Here is a drawing of similar beasts from the top of stirrups found in Denmark, from the viking period:

This symbolic cross on the Farr stone can be compared with a person, the mound representing the sacral vertebra, the shaft the vertebral column, and the circle the crown of the head, around which is the nimbus or halo of the saints. This symbolism relates to the inward spiritual journey of the saints and sages. The two beasts within represent man's worldly and anti-spiritual tendencies, lust, greed, and the like, which must be overcome before he can "ascend" to the state of True Man, through a mystical re-birth to the state of the twice-born. To help explain this, here are extracts from the writings of two sages. First, Abraham Lambspring, a noble ancient philosopher:

"the Sages do faithfully teach us that two strong lions, to wit, male and female, lurk in the dark and rugged valley [of the soul]. These the Master must catch. Though they are swift, fierce, and of terrible or savage aspect, he who by wisdom and cunning can secure and bind them, and lead them . . . of him . . . it may be said . . . that he has merited the meed of praise before all others, and that his wisdom transcends that of the worldly wise."

Second, Hermes, who represents the wisdom of the ancient Egyptians:

"The soul must begin by warring against itself, and stirring up within itself a mighty feud, and the one part of the soul must win victory over the others, which are more in number. It is a feud of one against two, the one part struggling to mount upward, and the other two dragging it down; and there is much strife and fighting between them. And it makes no small difference whether the one side or the other wins, for the one part strives towards the Good, the others make their home

among evils; the one yearns for freedom, the others are content with slavery. And if the two parts are vanquished, they stay quiet in themselves, and submissive to the ruling part; but if the one part is defeated, it is carried off as a captive by the two, and the life it lives on earth is a life of penal torment. Such is the contents about the journey to the world above. You must begin by winning victory in this contest, and then, having won, mount upwards."

Regarding the mystical death and rebirth, St. Thomas Aquinas wrote:

"No creature can attain a higher grade of nature without ceasing to exist."

And the anonymous text of the *Sophic Hydrolith* or Waterstone of the Wise says:

"And through this spiritual dying . . . all his actions have a heavenly source, and no longer seem to belong to this earth, for he lives no longer according to the flesh, but

according to the spirit . . . in works that stand the test of fire."

And a modern writer, Lucy Menzies, wrote:

"this dying to the self is the secret of the saints."

We have quoted at length in order to explain this important piece of symbolism. Just as there is a vertical symbolism of the cross, and also a centripetal one represented by the wheel-cross, so there is this vertical symbolism of the human person, and another which regards the "heart" as spiritual centre; God above, and God within.

The illustration on the next page, of an upright cross-slab from Bressay, which was moved to Edinburgh, shows a wheel-cross, and above it a man "torn between two beasts." In this case the two beasts are around the periphery of the wheel-cross, instead of below the shaft, giving a change from vertical to centripetal symbolism. The cross-slab itself, of course, may still be seen as implying the world-axis. The lower part of this slab shows ecclesiastics with crosiers, and animals beneath them. We

also illustrate the back of this slab, with a wheel-cross made of a single interlaced strand.

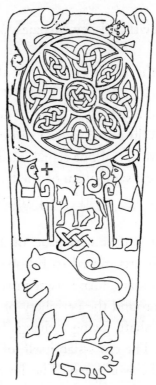

Front of cross-slab from Bressay.

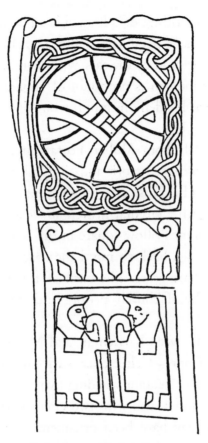

Back of cross-slab from Bressay.

A related symbolism, of a human head between two beasts, occurs on the cross of Papil, Isle of Burra, Shetland. In this case, the beasts hold the head by the ears, with their beak-like mouths, and here the symbolism is no doubt of subliminal suggestions whispered by invisible demons into the ears of men. Beasts without, and beasts within.

The cross-slab from Aldbar, Forfarshire, shows a combination of fine interlaced work and simple key-patterns of the Greek fret type. This cross clearly represents the symbolism of the world-axis with a circular heaven above and a square earth below. The apparent hollow square in the centre of the square earth symbol brings back to mind the space in the mound at the base of the Farr cross. The back of this slab shows a descending hierarchy of church, people, and animals. It also features a harp.

At Glamis, between Kirriemuir and Meigle, there is a slab bearing on the front a Celtic cross surrounded by figures and symbols, including a centaur wielding two axes, two figures with axes, a cauldron and a dish with two circular handles. Much of this decoration may have been ornamental, but the cauldron, which has two human figures plunged into it, is often a symbol

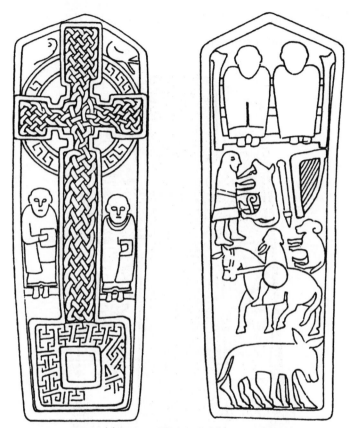

Cross-slab from Aldbar.

of rebirth or rejuvenation. The reverse side of this slab shows a serpent, a fish and a mirror.

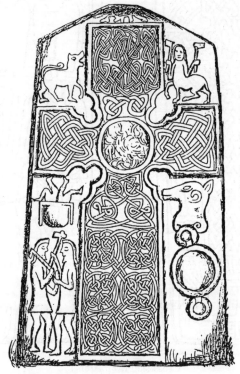

Cross-slab at Glamis, Forfarshire.

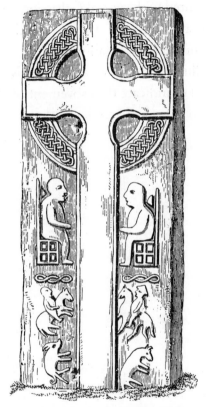

Cross at Kirk Maughold, Isle of Man.

The cross-slab on the previous page shows the circle outside the cross, ornamented with typical Celtic interlaced work. Either side of the shaft, we see the descending hierarchy of Christ/heaven, church, people, animals.

The cross illustrated below, also from Maughold, has the circle ornamented to indicate the movement of the turning heavens. There are two concentric circles in the centre of the cross:

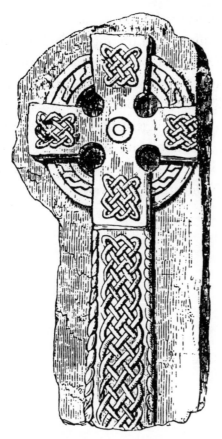

Rough-hewn cross-slab, Maughold, Isle of Man.

The cross illustrated opposite, also from Maughold, shows a Scandinavian influence in the interlinked ring design forming the axis or shaft. Like the previous example, this one has a circle in the very centre of the cross. Although the wheel-cross in its entirety was originally a symbol of Christ derived from the chi-rho monogram, it is likely that the outer circle came to symbolise heaven (in conformity with the ancient symbolism) and the centre of the cross, Christ in the centre of heaven, represented by the inner circle(s) mentioned above.

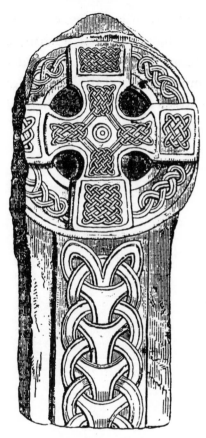

Cross, Maughold, Isle of Man.

The segment of a damaged runic cross opposite shows the Scandinavian chain-link axial design changing into tree-like branches where it enters the wheel; a reminder of the link between the stone monument and the Tree of Life. The runic inscription, part of which is visible on the right of the shaft, states that *Thirketil raised it for Ufaig son of Kiliais.*

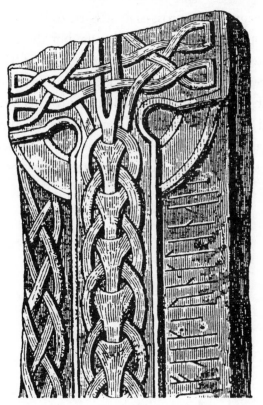

Part of cross in Braddan churchyard.

The design on the cross-slab at Kirk Andreas, Isle of Man, illustrated opposite, has no outer circle, but there is one in the centre. Note the dove and cock on the arms of the cross; the dove represents peace, and the cock announces the dawn which associates it with the sun. We shall return to this last point later on. Around the cross, the slab is decorated with a hunting scene with stags and wild boars. Perhaps this kind of decoration was not always so much symbolic as there to attract the people's attention.

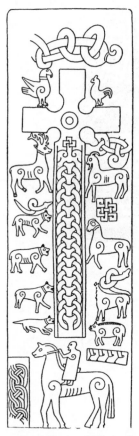

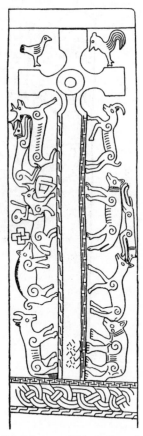

Cross of Arinborg at Kirk Andreas. Cross of Arinborg at Kirk Andreas (reverse).

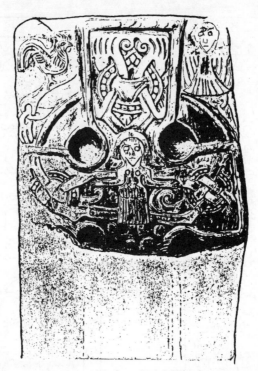

Cross-slab from Kirk Michael.

The fragment of a cross-slab on the opposite page, illustrated from Kermode's *Manx Crosses*, from Michael, I.O.M., shows, according to Kermode, Christ in ascension in the centre, and there is a cockerel, perhaps a symbol of the Resurrection, and a winged figure, perhaps an angel or else the Third Person of the Trinity either side of the upper part of the cross.

FREE-STANDING CROSSES

The most characteristic of the Celtic shaped crosses have a vertical ornamented axis with a wheel-cross on top, and a square base. They conform to the symbolism of typical market crosses, of a square earth linked to a round heaven by a shaft symbolizing the world-axis. The shaft, however, has lost its octagonal section, being square or rectangular to provide suitable surfaces for the various types of developed Celtic ornamentation, itself often symbolic, and compensating for the loss of the symbolism of the directions of space. There is, however, wide variation in the forms of ornamented free-standing Celtic crosses, and many of those which are carved from a single block of stone have no special base. Crosses constructed from more than one

block of stone generally have the parts united by mortise and tenon joints.

On the next page we illustrate the cross at Castledermot, Co. Kildare, as an example of one of the high crosses of Ireland. The rectangular base block slopes inwards as it rises, relating the idea of the stepped pyramid or primordial mound; it is decorated with a hunting scene which was probably intended to arouse the interest of the ordinary folk. The shaft is divided into decorated panels illustrating scenes from the Bible, for this type of monument is rightly called a cross of the scriptures. The circle of the wheel-cross represents heaven, and the central panel of the cross itself represents Christ by a portrayal of the crucifixion.

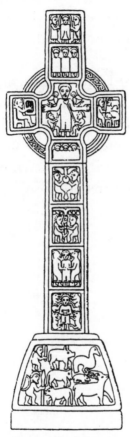

Cross at Castledermot.

We illustrate the high-cross of Durrow, and opposite, that of Muredach at Monasterboice, both examples of crosses of the scriptures.

In Scotland, on the Island of Iona, there is a cross known as St. Martin's. Its front is decorated in a similar way to the Irish high crosses, with biblical scenes on the shaft, and the very centre of the cross has a representation of the Virgin and child. The ornamentation on the back is, however, purely decorative. This cross stands on a square, stepped base.

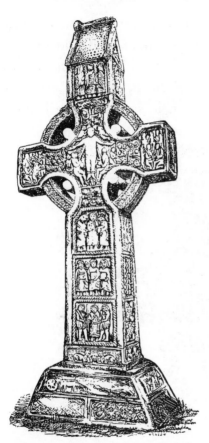

High cross of Muredach, Monaasterboice.

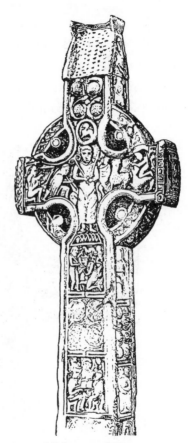

High cross of Durrow.

We have now seen the highest heaven represented in the centre of the cross by the crucifixion, the Virgin and Child, or, earlier, by a circle. The cross at Ruthwell, Dumfries, Scotland gives us two more symbols in its centre. On the front the centre is made up of a circle containing a triangle, symbol of the Trinity:

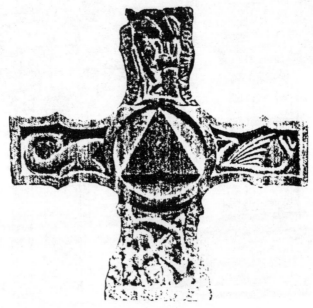

Upper part of cross of Ruthwell (front).

The back of this cross shows, in its centre, a face radiating light, a solar symbol of Christ as source of divine light:

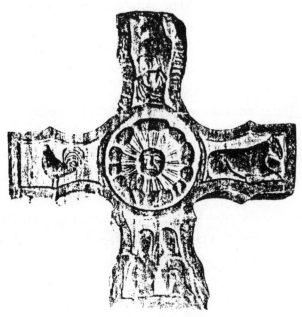

Upper part of Ruthwell cross (back).

A cockerel on one of the arms of this cross may be associated with this solar symbolism, for it heralds the dawn and the rising sun. We have previously noted a cockerel on the cross of Arinborg on the Isle of Man. Another solar connection of the cockerel is its frequent association with the colour gold. Also, on many traditional weather-vanes, the cockerel sits above the symbol of the directions of space, like the sphere above the octagonal shaft of many market crosses!

The free-standing cross of Dupplin, like the previous one, is yet another Scottish example that does not have the outer circle. Perhaps the mason thought the detached outer circle too difficult to execute, or else that the inner circle was sufficient. This cross, illustrated on page 158, has Celtic interlaced work, spiral ramshorn designs, and key patterns, as well as pictorial panels. The very centre of this cross takes the form of a raised boss, decorated with what appear to be solar radiations, symbols of divine light. Here is a drawing of the boss from the back of the cross. It is only fair to add, however, that a radial pattern is an obvious way to decorate the perimeter of a boss.

Boss in centre of Dupplin cross (back).

Some of the crosses from the Isle of Man, dating from the Scandinavian period, have single or concentric wreath-like rings in the centre:

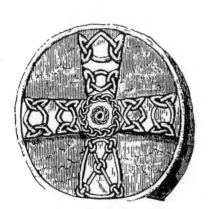

Left; cross in Treen chapel near Ballaglass, Kirk Maughold. Right; figure on shaft.

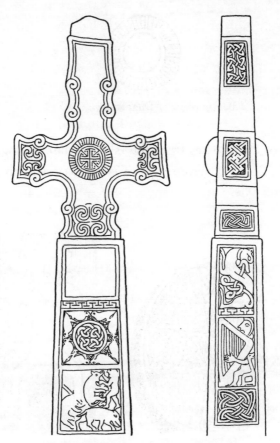

Cross at Dupplin (front & left side).

The figure on the shaft of the Ballaglass cross is included without comment, and, to return from inner circles to outer, here is a fine example with an outer ornamented circle:

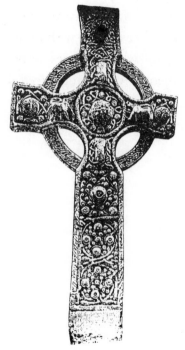

Free-standing cross at Kildalton, Islay.

Now we shall look at some crosses from Wales, to see contrasts in symbolic emphasis, and some fine examples of Celtic ornamentation.

At one extreme we have the Neuadd Siarman cross from Brecknockshire. This cross emphasizes the symbolism of the world-axis, being made like a pillar with no projections from the wheel-cross at the top, which merges imperceptibly with the shaft. It is decorated entirely with interlaced work.

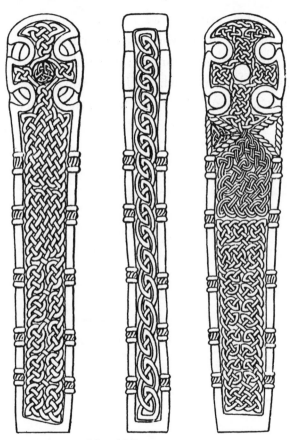

Neuadd Siarmann cross.

At the other extreme, we have the great wheel-cross at Margham. In this cross, which is constructed from blocks of stone, there is a massive rectangular base linked by a shaft with an equally large solid stone wheel. The emphasis here is on the wheel-cross (although the shaft has been shortened through damage).

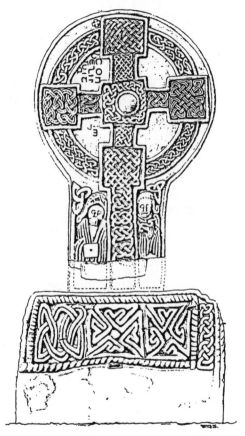

Great wheel-cross of Conbelin at Margham.

Many of the intact crosses of Wales, however, fall between these two extremes. The cross at Nevern, Pembrokeshire, is a fine example in which the overall shape stresses the symbolism of the world-axis, yet the wheel-cross is distinct. The same is true of the Cross at Carew. The one at Penally is interesting because the plaitwork on the lower part of the shaft changes into a pattern of conventional foliage just over half-way up, reminding us of the ancient link between the stone world-axis symbol and the Tree of Life.

The cross at Llanbadarn Fawr, near Aberystwyth, has, like two of the Scottish crosses we looked at, no outer circle.

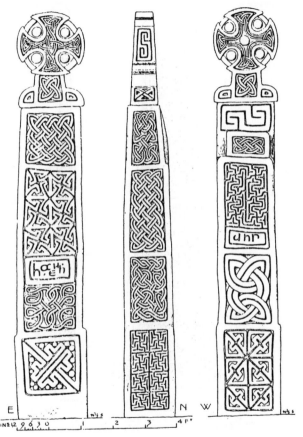

Nevern cross.

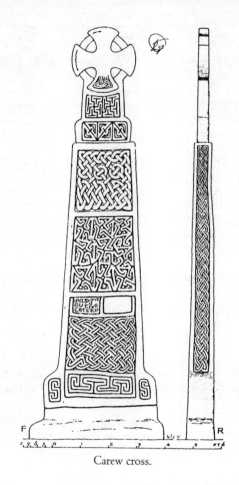

Carew cross.

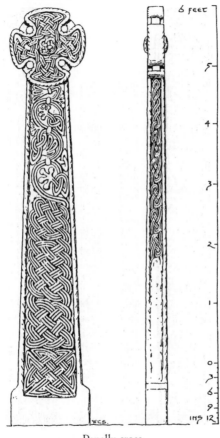

Penally cross.

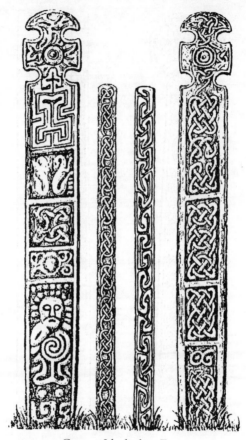

Cross at Llanbadarn Fawr.

The next two crosses emphasize the symbolism of the world-axis by having greatly elongated shafts. First, we give Mr. Byam Shaw's drawing of the cross in Mylor churchyard, Cornwall, with a local resident, Mr. John Tregenza, standing alongside it. It was found half-buried with its head below ground, in 1870. It is 17'6" high, but part of it is sunk in the ground.

Finally, we come to the churchyard cross of Gosforth in Cumberland, which stands about fifteen feet high, making it tall and slender like a tree. The stepped base was discovered by excavation in the 1880s. This cross is often described as Anglo-Nordic, but Gosforth was within the sphere of influence of the Northumbrian Church with its Celtic origins. The local population there was still Celtic with Norse settlers. It is said that even today some of the older shepherds in the Lake District count their sheep in Welsh! We give W. G. Collingwood's drawing of this cross, with the base added from a drawing made by C. A. Parker at the time of the excavation. Collingwood thought that this stone cross was based on the form of the old rood crosses that were much smaller, and in wood. Note that the pattern on the lower part gives the impression of bark, linking this cross

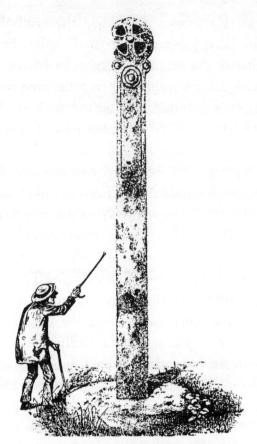

Cross, Mylor churchyard.

with the Tree of Life; also the stepped base comparable with the base of many market crosses.

The Gosforth cross, standing on a stepped pyramid, has brought us back full circle; back to the ancient pillar stones, Silbury Hill (which was built as a seven-stepped pyramid), and the pagan market crosses at the beginning of this book. All we wish to add here, is that in the Celtic cross there is no question of paganism infiltrating Christianity, but simply of Christianity adopting a form of symbolism which is universal.

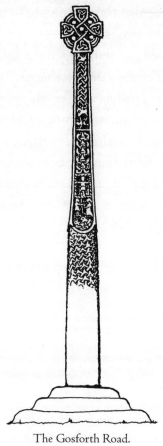

The Gosforth Road.